Spoken Art
Too Brave to Back Down

D1211466

Rita P. Mitchell and Brittany A. Mitchell

DEDICATION

This book is dedicated to anyone searching for inspiration, truth, affirmation, or simply a bright light in the darkness.

ISBN: 978-1-7329102-2-5 (Paperback)

Cover design: Brittany A. Mitchell
Interior design: Brittany A. Mitchell

www.RitaPMitchell.com

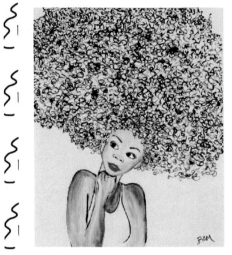

LET THE SUN IN — Brittany A. Mitchell 2021, acrylic on canvas

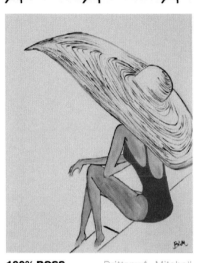

100% BOSS — Brittany A. Mitchell 2021, acrylic on canvas

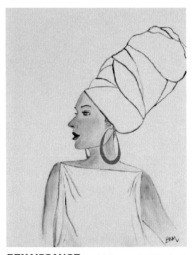

RENAISSANCE WOMAN — Brittany A. Mitchell 2021, acrylic on canvas

What is Spoken Art?

by Rita & Britt

THE ORIGINS

Rita: The origin of Spoken Art came from a series of paintings my daughter, Britt, created. After an unsuccessful online search for phenomenal living room art, Britt declared that she would create a one-of-a-kind art series made uniquely for our home. She decided to paint three individual pictures of strong black women that when combined, would create one large statement piece. I fell in love with her sketches and I was immediately on board. As each painting began to take form, I thought to myself, I am these three women. As I reflected on the art, I saw my life's continuum in the three women reflecting back at me. Each painting represented a phase of my life: as a young girl, as a maturing woman, and as myself today, fully grown up.

Britt: For me, I wanted to both find and define my artistic voice because throughout my life, my art has been defined by others (as you will see throughout this book). In high school, my art was defined by my art teacher and her classical art techniques. As I grew up, my art was defined by what my friends and family would want for holidays, birthdays, and special occasions. With the "Spoken Art" series (three black women) I wanted to search my own soul for subjects that inspired me first, and for techniques that I defined and created. In this art series, the shading is not quite perfect, the lines are not quite complete, but the feeling is bold, bright, beautiful, and uniquely me.

WHAT IS SPOKEN ART?

Rita: When I saw Britt's art it spoke to me and it in turn made me want to speak to it. Her art inspired me to express my feelings about my life lessons thus far. The women in this series reminded me of one of my favorite songs, "He Loves Me" by Jill Scott. As Jill sings about being in love she says that "you move me to chorus" meaning she was so happy that she had to sing. Britt's art moved me so much that I had to write. Her art actually moved me to written expression.

Britt: When mom came up with the phrase "spoken art," I thought it was enlightening because I typically think of words coming before art. My creative process always begins with words and a lot of research, so to think that mom would have the reverse process (art to words), was a very interesting and exciting idea.

BRINGING BACK THE ORIGINAL LOGO

Britt: I designed the "Phenomenal Woman" logo (on the left) when mom first began her post-retirement journey from launching her writing career as a contributing writer for Black Enterprise Magazine in July 2017 to speaking on the TEDx stage in November 2017 with her talk, "Own Your Power." To me, the logo embodies my mom's signature look: fabulous curly hair and bright red lipstick. However, the logo also symbolizes being phenomenal in your own right. This logo will represent our new foray into art, fashion, and food as we look to expand our brand from its career-focused foundation: keynote speaking, leadership workshops, and the pocket mentor book (*Own Your Phenomenal Self: A Guide on Character, Success, and Leadership*).

FOREWORD

by Rita & Britt

Spoken Art is weaving words and art into meaningful messages that we hope will invoke inspiration and aspiration. For us, this book is about stepping out of the darkness and into the light through the power of Spoken Art.

WHY ARE WE WRITING THIS BOOK?

Rita: I'm writing this book because I'm finally inspired to write again and I haven't been for quite a while. I also aspire to inspire young girls to their hidden greatness and beauty. Britt and I both feel that there should be more positive messages out there specifically directed to young girls that affirm their importance, impact, and their power to choose their own destiny in our society. I want parents to be able to give this to their daughter, a grandmother to give this to her granddaughter, an uncle to give this to his niece, a teacher to give this to his/her students. I want this message of doing good, being good, and being extraordinary to be the norm and not what is unique. My message: YOU were uniquely created and YOU have greatness inside of you.

Britt: For me, this project unexpectedly became a way to showcase 20 years of my art and my artistic talent. I've always wanted to sell my art without actually selling my art. Through this book and my art store, I can both share and sell my art while still maintaining ownership of the original works that mean so much to me.

Rita: Also, I want you as the reader to know that everyone has the ability to create. It is important to feel important and creativity does just that. Creativity is unique to each person and sparks joy and confidence. Don't be afraid, be fearless and let your creativity come to the surface... nurture it, grow it, share it. Doing what is in your heart makes you a happy person, a more whole person, and ultimately a better person.

WHAT WE WANT YOU TO EXPERIENCE

Rita: Inspiration and affirmation. We want you to be inspired to create and we want you to seek out the words, phrases, and art that affirms who you are as a person.

Britt: Agreed. We want the book to create a sense of wonder and spark creativity.

Rita: Later in this book Britt and I share our personal affirmations. For both of us, these affirmations came from very dark places when we were each looking for the light. If you or someone you know is in a dark place, we want this book, our words, and our art to be a beacon of light and hope.

Spoken Art is about declaring your truth and your heart's desire...

I am strong in mind, spirit and faith
I am smart... thus I will live and mak
decisions with confidence.

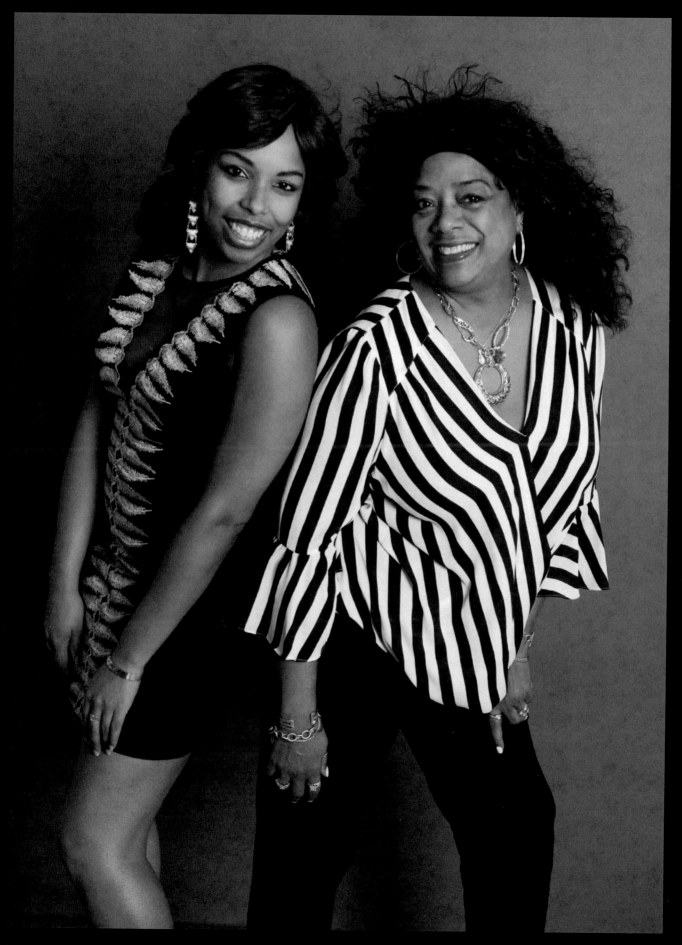

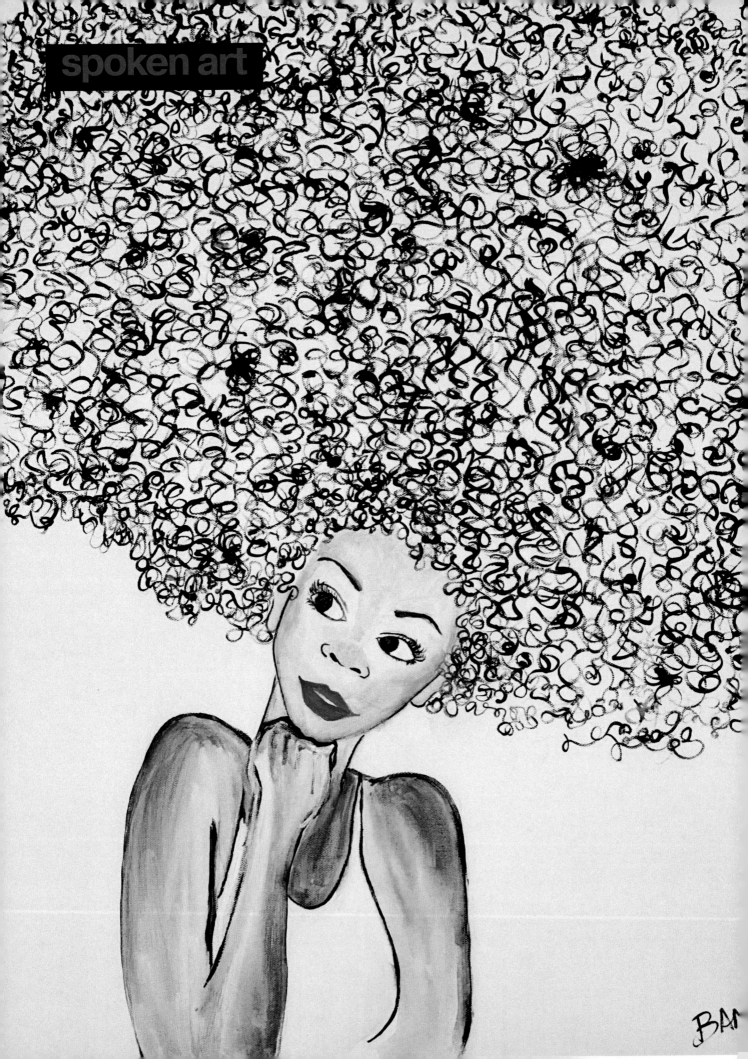

When I Grow Up

I will be kind, I will care and I will surround myself with people who are strong, caring and kind

I will be brave and courageous and I will dare myself to live my best life

When I know better I will do better, when I learn I will teach, as I rise I will lift

I will have grace, gratitude, and patience and I will forgive myself for not being perfect

I will be bold, beautiful, strong and fearless and I will have abundance to share and make a difference in the world

I will stay in faith, not be intimidated, find my purpose and live a phenomenal life

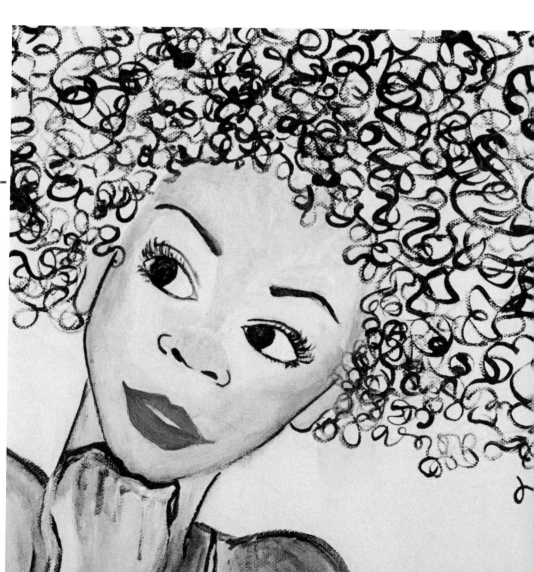

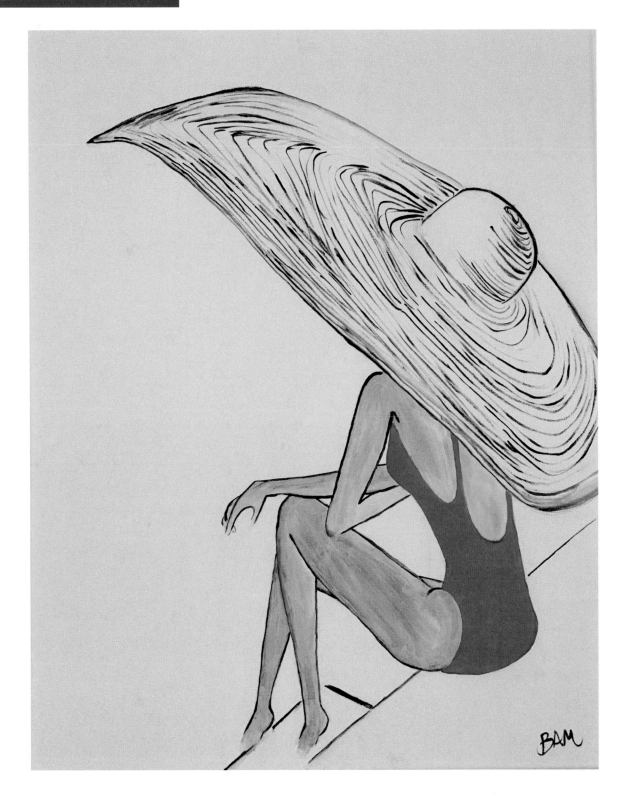

How Will I Live?

will put God first in all things.

will find joy, peace, and the blessings in each day

will control what I can control and let the rest go

will take care of my family with all of my might, all that
have, and all that I am

will take care of my body because it is the only one that
have and I want it to last

will be adventurous, try new things, and continue to
tretch and grow.

will love others like I want to be loved AND I will love
ne and know that I am in fact enough

will have equity in all areas of my life

will be successful in all things that I put my hand to

will "shut the room down" whenever and wherever, be-
ause I got it like that!

will not be afraid but I will be brave... I will laugh, love,
nd live my life full out

Time starts out slow but life is fast and fleeting, so take your time and enjoy each moment

You were made unique and are a phenomenal creation so reach fo the extraordinary... it is possible

Find what makes you happy and gives you joy and then live your lif with purpose, passion, and fun

Always keep the Golden Rule. It is a true guide in living your best li and becoming your best self

It is better to give than to receive. Work to have abundance so you can give freely and help those in need

Surround yourself with true family and true friends, they are both those who accept you, support you, love you, and fight for your happiness, success, and your survival

Life's Armor: faith, patience, charity, humility, hard work, honesty integrity, kindness, forgiveness, truth, grace, wisdom, gratitude and hope

Don't be afraid, be fearless...your steps are numbered...have faith and BELIEVE

Salvation is your greatest gift... don't throw it away

What is my legacy?

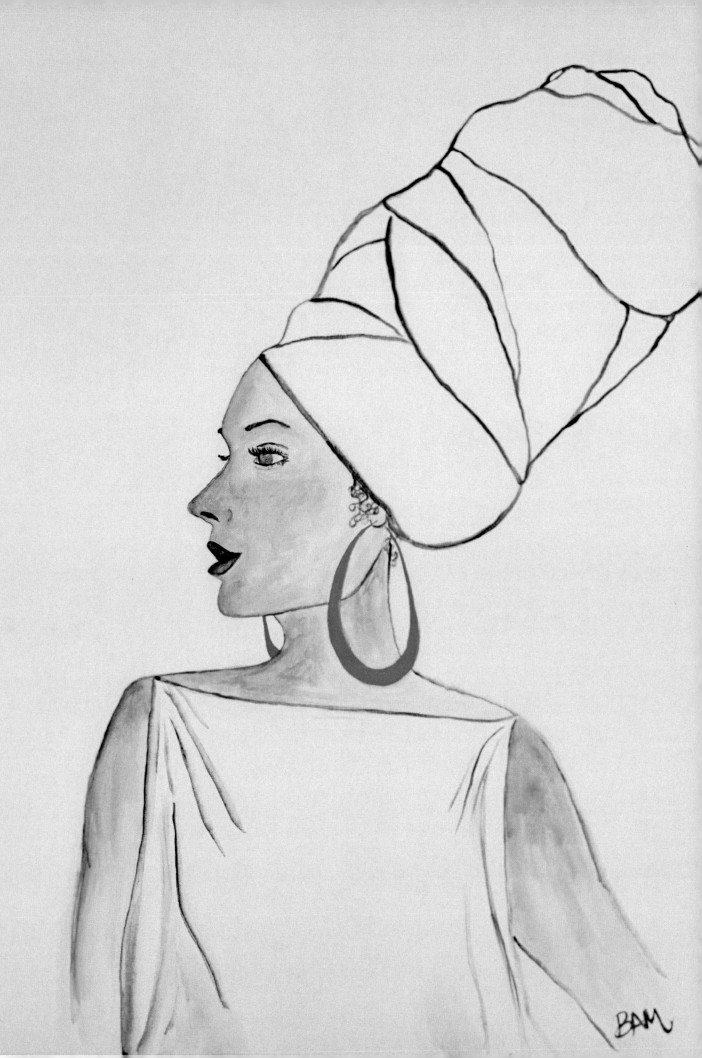

"I am more than a warrior, I am a conqueror."

Rita P. Mitchell

ABOUT THE ART

Britt: In the summer of 2018, when Mom and I were in New York City, I captured this photo of her in her black and white striped dress and zebra-esque purse. The stark black and white patterned silhouette really spoke to me at that particular moment. While mom was going through the throes of her divorce, I wanted to paint something that would bring her back to herself and I was immediately brought back to this photograph. However I wanted an even bigger contrast against the black and white. Mom loves fresh flowers and buys them every week, so I removed the city streets and replaced them with a flat red background spotted with large roses in full bloom that seemed to be floating all around her.

Rita: I loved this piece Britt made for me. It reminded me of my own strength and power. I have power over my destiny and I choose when to stay and when to go. Not only when to go, but where to go.

Britt: In high school, I was very interested in pointillism and the idea that a complex picture could be made up solely of teeny tiny dots, as small and simple as the humble period at the end of a sentence. There were two photographs that I used to create the pointillism of mom (on the right page) and of me (on my Art & Affirmations page). The image of mom is from an old photograph of her in her 30s that I found in a box full of family photos. The image of me is from a picture someone took of me at the annual Shakespeare Festival in Nashville in 1998. Together we are reflections of each other, looking into our futures, intertwined and ever hopeful.

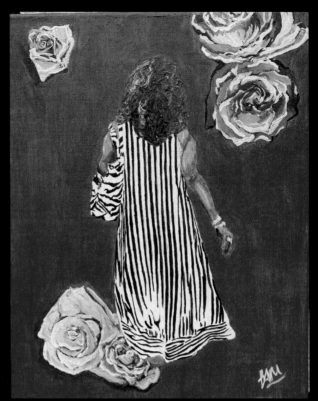

OWN YOUR POWER

Brittany A. Mitchell
2020, acrylic on canvas

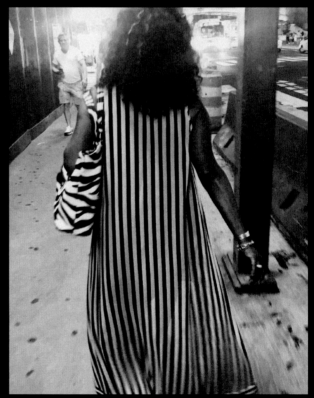

WOMAN ON A MISSION

Brittany A. Mitchell
2018, photograph

Art & Affirmations

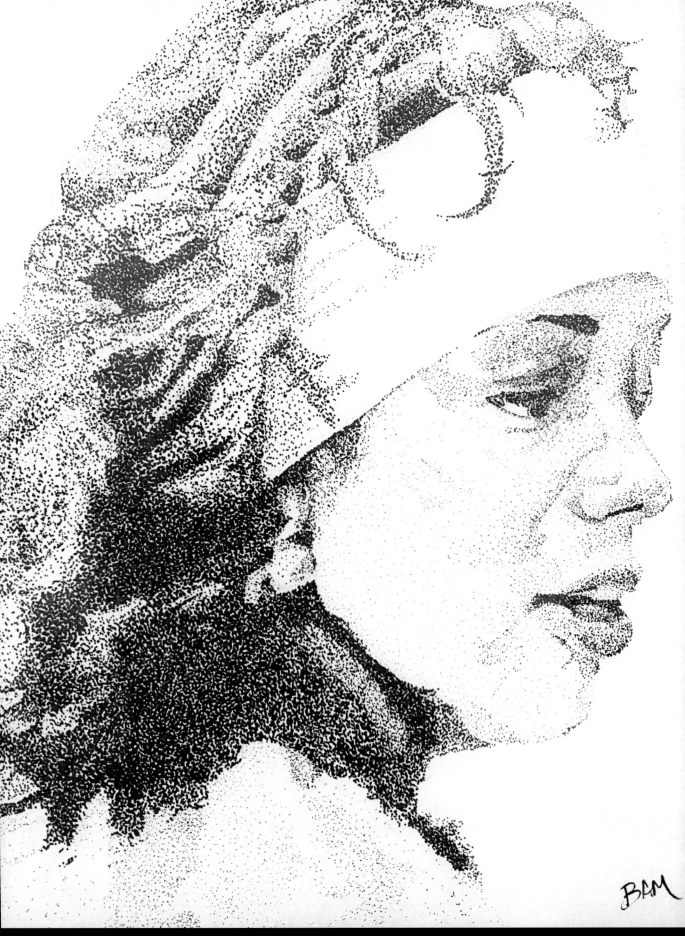

HOPEFUL MOTHER

Brittany A. Mitchell
2003, ink on artboard

Rita's Affirmations

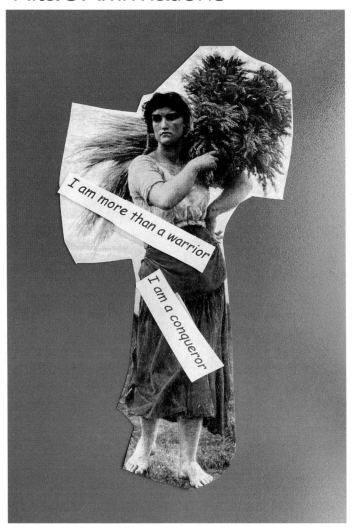

I am more than a warrior

I am a conqueror

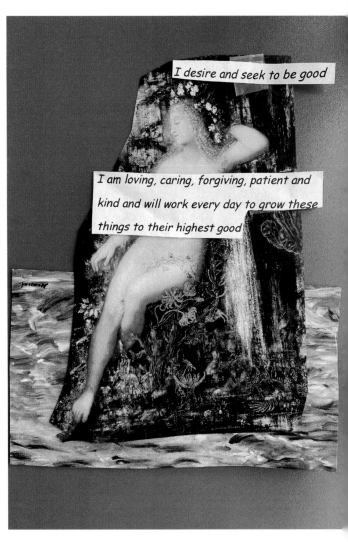

I desire and seek to be good

I am loving, caring, forgiving, patient and kind and will work every day to grow these things to their highest good

WHAT DO YOUR AFFIRMATIONS MEAN TO YOU?

Rita: These affirmations came to me at an overwhelmingly dark time in my life. I was at the beginning of my divorce from 40 years of marriage. I was defeated, depressed, and directionless. I felt diminished. All of who I was and what I had achieved was wrapped up in something that no longer seemed to exist... something that I truly believed would have lasted my entire lifetime. These affirmations became my anchor and helped me get back to my true north. They helped me put a stake in the ground that no matter what had happened to me, these words would define who I was and who I am. I named them, claimed them, stuck them firmly in the ground, and held on tight with all of my might.

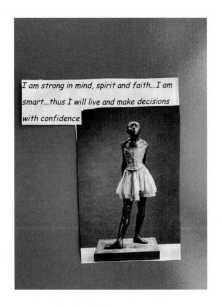

I am strong in mind, spirit and faith...I am smart...thus I will live and make decisions with confidence

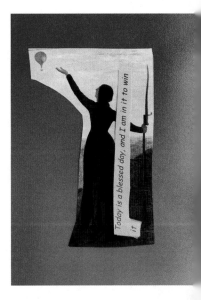

Today is a blessed day, and I am in it to win it

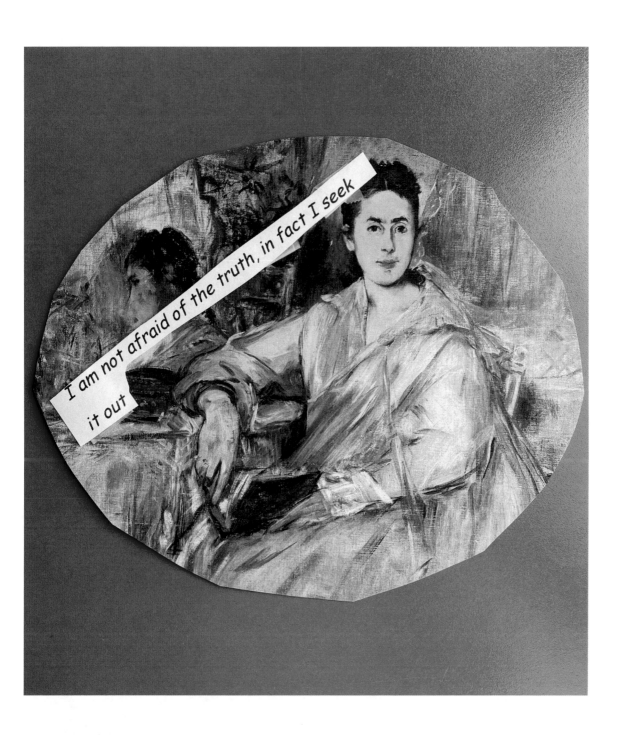

I am not afraid of the truth, in fact I seek it out

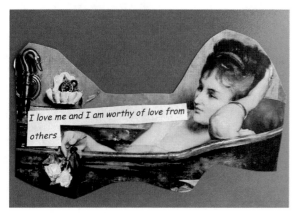

I love me and I am worthy of love from others

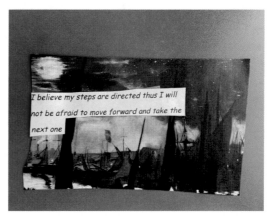

I believe my steps are directed thus I will not be afraid to move forward and take the next one

Rita's Affirmations

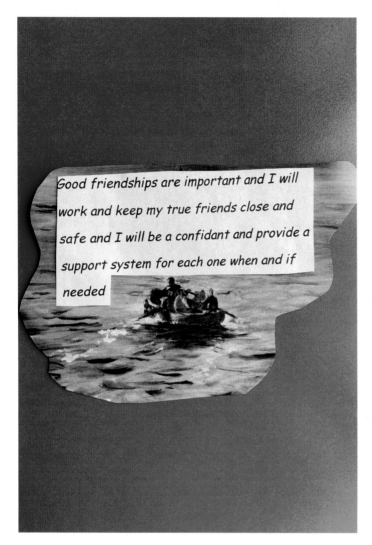

Good friendships are important and I will work and keep my true friends close and safe and I will be a confidant and provide a support system for each one when and if needed

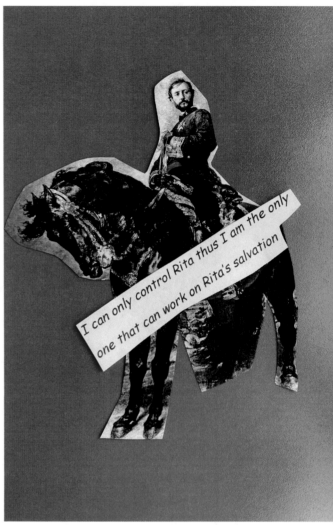

I can only control Rita thus I am the only one that can work on Rita's salvation

SPEAK YOURSELF OUT OF DARKNESS

Rita: To me, the affirmations are another example of Spoken Art. First and foremost, I wrote the affirmations to bring me out of the darkness. The affirmations were both "the things that made me Rita" and "the things to which I could anchor myself." Once my fifteen affirmations were completed, I wanted to frame the words in an inspiring way so that I could see them come to life every day. Indecisive of how to bring my vision to fruition, Britt handed me an art history book and said "why don't you begin with this?" When I looked through the book I decided to make it my "scrapbook paper" to frame each affirmation. I tore out all of the images of the paintings, sculptures, and art that spoke to me. Then I took the words from my soul, my affirmations, and matched them to each piece of art to again create Spoken Art.

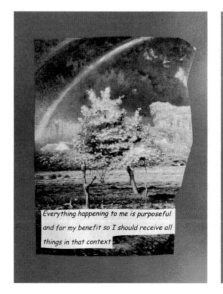

Everything happening to me is purposeful and for my benefit so I should receive all things in that context

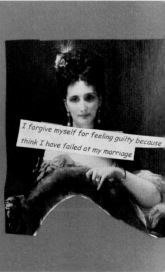

I forgive myself for feeling guilty because think I have failed at my marriage

THE POWER OF VISION

Rita: I am a big believer in vision boarding. In fact, I have a whole methodology on how to create vision boards which I use with clients to help them define their journey to their desired success. I knew after my divorce that I would have to use my own methodology on myself to rebuild what was broken. I had to let go of my past vision and create a new vision for my new life. My affirmations were created prior to me creating my current vision board. My affirmations helped me to establish that only I am in control of myself and I refuse to be lost in someone else's sauce. Affirmations help you find yourself and ground yourself so you can step into the light.

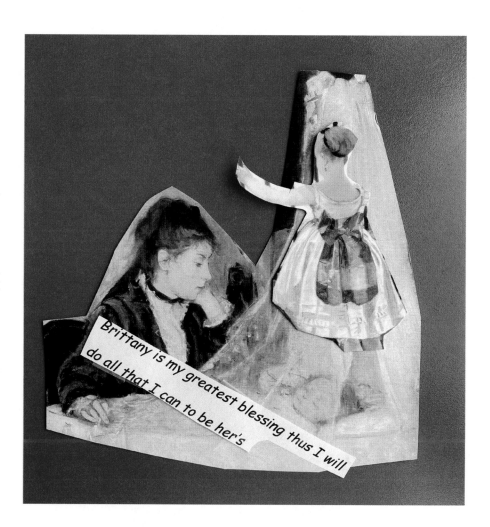

Brittany is my greatest blessing thus I will do all that I can to be her's

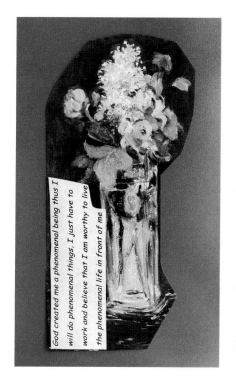

God created me a phenomenal being thus I will do phenomenal things, I just have to work and believe that I am worthy to live the phenomenal life in front of me

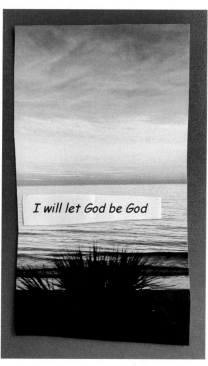

I will let God be God

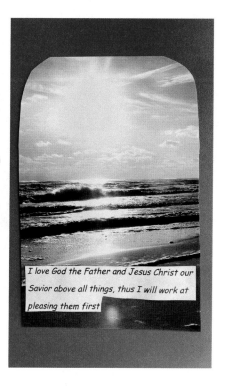

I love God the Father and Jesus Christ our Savior above all things, thus I will work at pleasing them first

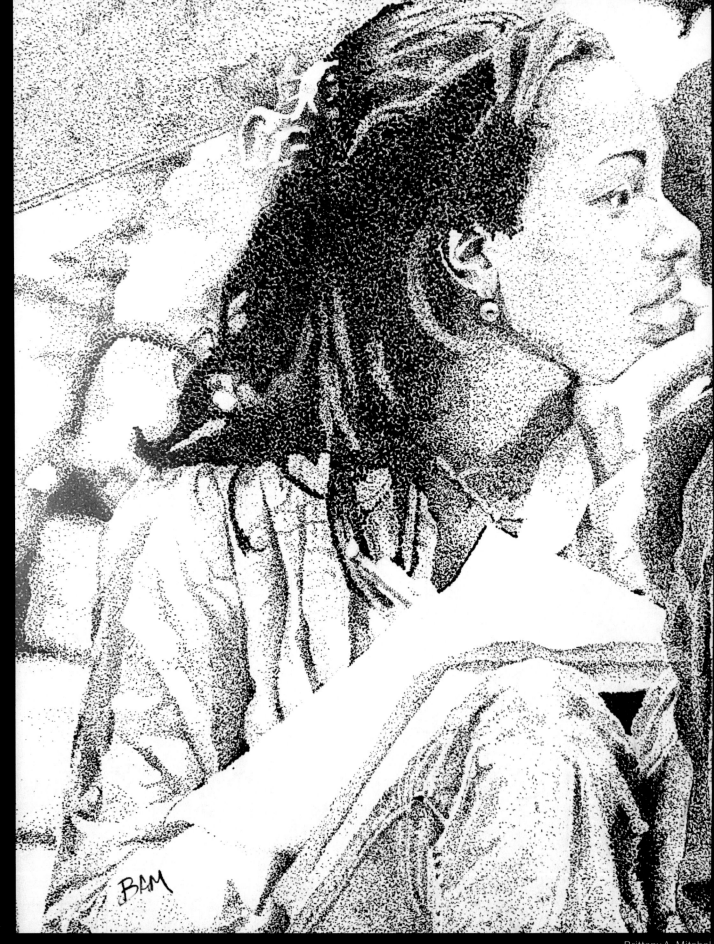

EVER HOPEFUL DAUGHTER

Brittany A. Mitchel
2003, ink on artboard

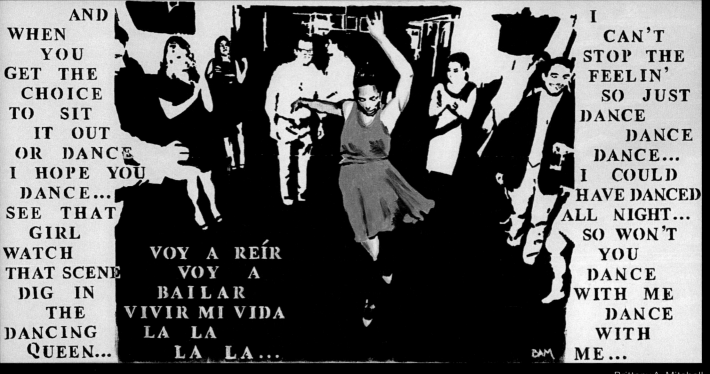

AND WHEN YOU GET THE CHOICE TO SIT IT OUT OR DANCE I HOPE YOU DANCE... SEE THAT GIRL WATCH THAT SCENE DIG IN THE DANCING QUEEN...

VOY A REÍR VOY A BAILAR VIVIR MI VIDA LA LA LA LA...

I CAN'T STOP THE FEELIN' SO JUST DANCE DANCE DANCE... I COULD HAVE DANCED ALL NIGHT... SO WON'T YOU DANCE WITH ME DANCE WITH ME...

BAM

Brittany A. Mitchell
2018, acrylic on canvas

MITCHELL STREET

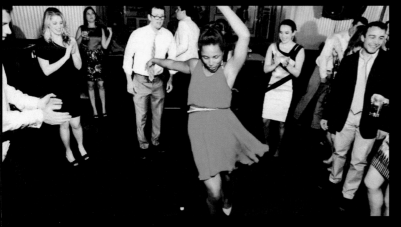

ABOUT THE ART

Britt: I am most myself in motion, dancing across a room. I love to dance and I love the joy that dance brings out of me. The photo to the left was taken of me dancing at a friend's wedding from graduate school. I think this photo captures how I feel when I dance, so I turned it into a statement art piece that has traveled with me across states as I have moved around the country. Speaking of Spoken Art, there are six songs incorporated into this painting from six genres of music that all evoke the spirit of dancing.

1. "I hope you dance" Lee Ann Womak
2. "Dancing Queen" ABBA
3. "Can't Stop the Feeling" Justin Timberlake
4. "I Could Have Danced All Night" Audery Hepburn
5. "Dance With Me" 112
6. "Vivir Mi Vida" Marc Anthony

"I am truly an artist. I already have all the talent I need inside of me to paint, play, and sing to my heart's desire. I have the power to create anything I can imagine or feel."

Brittany A. Mitchell

Art & Affirmations

Britt's Art

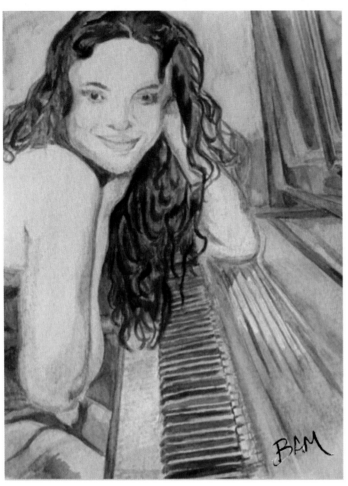

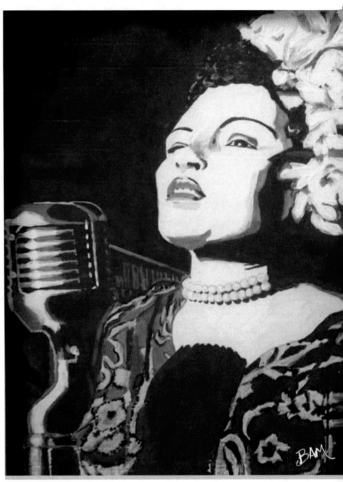

COME AWAY WITH ME

Brittany A. Mitchell
2002, watercolor

LADY DAY ON THE MIC

Brittany A. Mitchel
2016, acrylic on cardboard

ABOUT THE ART

Britt: Top left, *Come Away with Me* (Nora Jones on the piano) is a watercolor painting from high school. I'd like to believe that if I keep painting piano players, my own piano skills will come out of hibernation. Thus, it's no surprise that you will see a recurring theme of pianists, singers, dancers, and performers who inspire me across these pages. Top right is a cool, bluesy painting of *Lady Day on the Mic*. It's acrylic on cardboard, specifically an old box from USPS. In 2015, I went to Jazz Fest in New Orleans and while I was there I was surrounded by very moving and inspiring art. I painted Lady Day on the Mic for my mom for Mother's Day in 2016, hoping that she would be as moved by my art as I was by the artists in New Orleans.

On the adjacent page, *The Camels are Coming* is a very large work, also acrylic on cardboard. In high school, I would look through magazines for interesting photos from around the world. I loved this image of what felt like a stampede of camels that made me want to travel to northern Africa.

Of the three pieces on the bottom half of the page the two on the right are from my Advanced Placemen (AP) Art portfolio in high school centered on travel and culture. I used *American Made* (color pencil on black board) to represent America and I loved the fact tha the subject was of a soccer player, which is not stereotypically American, wrapped in the American flag The middle image, *For the Love of a Lotus* (acrylic or cardboard) I copied from a book on Indian art. My best friend in high school was Indian and I spent much of my free time diving into Indian food, dancing, movies, and the culture in general. I love the stillness o the women with the lotus flower. Lastly, to the left is my first pointillism, *Mirror Me*, which I copied from one o the photographs from Lauren Hill's album The Miseducation of Lauren Hill. It's a powerful image of reaching for your own reflection and it spoke to me with as much force as the strength of her lyrics.

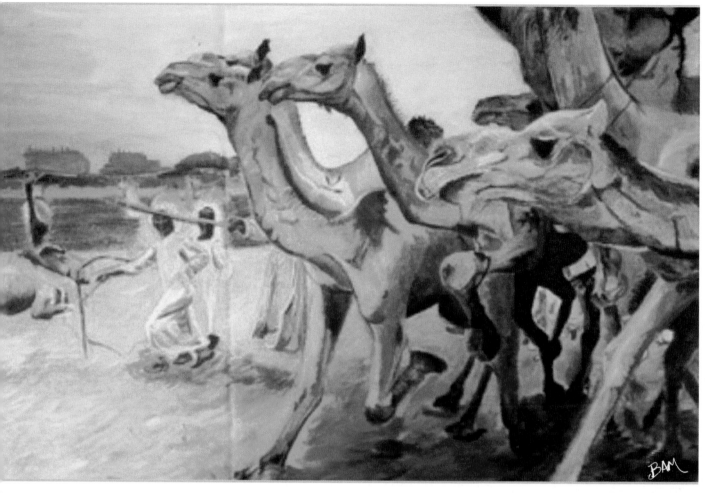

THE CAMELS ARE COMING

Brittany A. Mitchell
2003, acrylic on cardboard

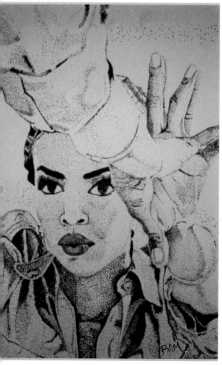

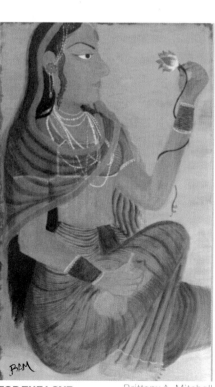

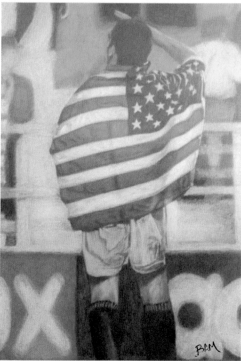

MIRROR ME

Brittany A. Mitchell
2002, ink on artboard

**FOR THE LOVE
OF A LOTUS**

Brittany A. Mitchell
2003, acrylic on cardboard

AMERICAN MADE

Brittany A. Mitchell
2002, color pencil on artboard

Britt's Art

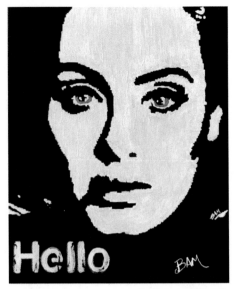

A SIMPLE HELLO
Brittany A. Mitchell
2018, acrylic on canvas

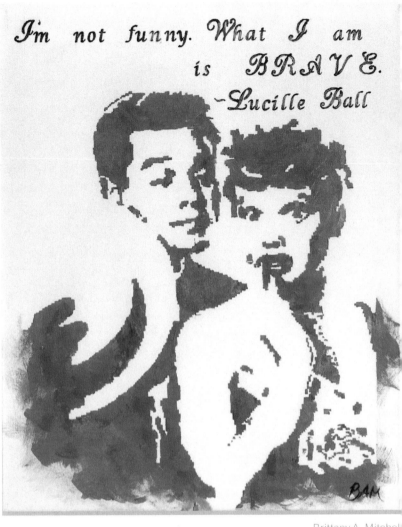

TOO BRAVE TO BACK DOWN
Brittany A. Mitchell
2018, acrylic on canvas

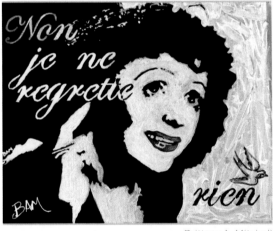

NO REGRETS
Brittany A. Mitchell
2018, acrylic on canvas

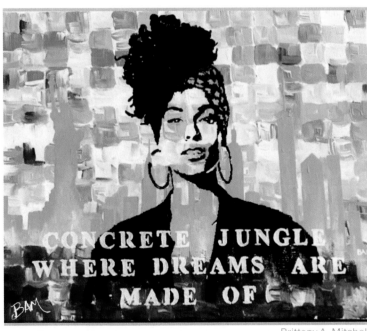

KEYS AND CONCRETE JUNGLE DREAMS
Brittany A. Mitchell
2018, acrylic on canvas

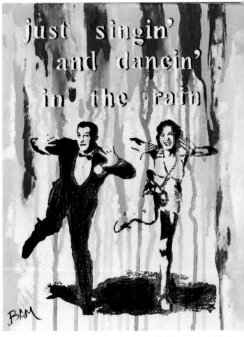

2 LUCKY STARS
Brittany A. Mitchell
2018, acrylic on canvas

ABOUT THE ART

Britt: I love the "Faces of Greatness" series because for the first time I started forming my own opinion about my art, how it should look and what I wanted it to invoke. For most of the pieces in this series, I chose a female performer who inspired me. I researched their lives and careers, chose an interesting photo, simplified each color photo to a two-toned black and white print, then created a hand-made stencil. From there I painted over the stencil emphasizing eye-catching aspects with shape, color, lyrics, and quotes creating a meaningful story for each one.

For example, I learned that Édith Piaf's real name was Édith Giovanna Gassion and "Piaf" was a nickname that means sparrow in French. Thus, I put a little sparrow at the bottom right corner of her piece, *No Regrets*. In the Alicia Keys piece, *Keys and Concrete Jungle Dreams*, I painted a faint green NYC city skyline in the background to allude to my lifelong dream to live and work in New York.

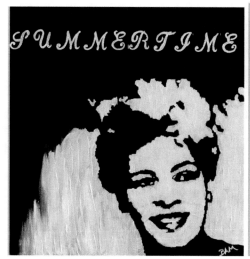 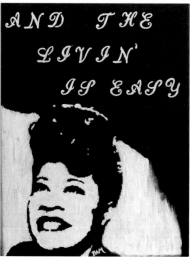

SUMMERTIME SISTERS

Brittany A. Mitchell
2018, acrylic on canvas

ABOUT THE ART

Britt: The Billie Holiday and Ella Fitzgerald combo painting, *Summertime Sisters*, began to intertwine as I read their stories. I realized that at some point both women had sung "Summertime," so I wanted to make each painting a continuation of the other.

Lastly, I want to call out the Anthony Bourdain piece, *Food for Thought*. I had every intention to focus on female powerhouses who inspired me, but after hearing the news of Bourdain's death, I was moved to make an exception. Cooking, traveling, and sharing culture with others is so important to me in my life, I wanted to capture Bourdain's quote, "Find out how other people live and eat and cook. Learn from them wherever you go." The black line across the top of "A. Bourdain" in the bottom right of the painting is there to symbolize a life cut off and gone too soon. The colors below represent how full of life his life was.

UNFORGETTABLE

Brittany A. Mitchell
2018, acrylic on canvas

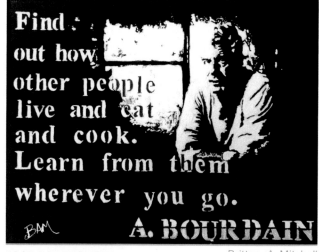

FOOD FOR THOUGHT

Brittany A. Mitchell
2018, acrylic on canvas

Britt's Art

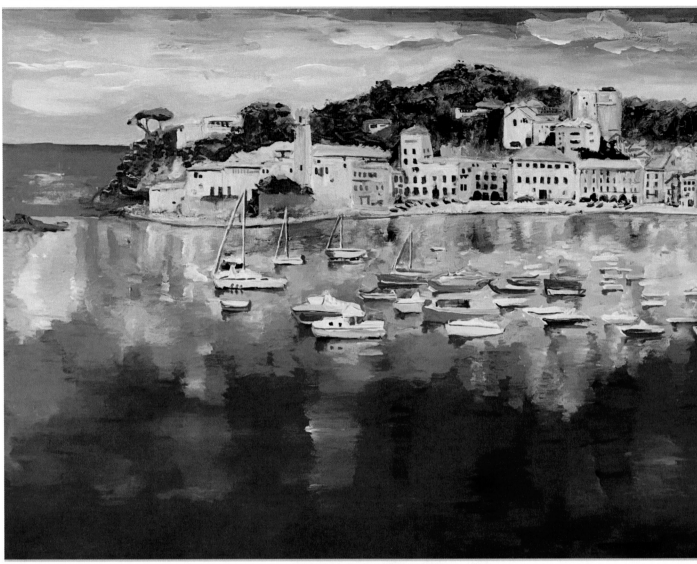

WISHING FOR ITALY

ABOUT THE ART

Britt: Welcome to the beach. Let's start with the *Venice at Sunset* painting at the bottom right of this page. I painted this image in high school and it was the first time I looked at my own art and thought, "wow, I might be onto something." It's a combination of some of my favorite artistic flares: impressionistic style, bright/bold colors, plus a warm and inviting subject. Moving to the left, I painted *Blue Skies and Sandy Shores* more recently in 2020 while I was in Gulfport, MS where my mom's side of the family is originally from. For me, the beaches of Gulfport have much more of a chill family vibe than the highly commercialized shores of Pensacola, FL and other more touristy beaches along the coast. In honor of the peace and simplicity, I wanted to practice a more minimalist style in *Blue Skies and Sandy Shores* but still maintain the rich colors of familiar ocean vibes.

The large image above, *Wishing for Italy*, is one piece I am most proud of. It went through quite a lot of different "personalities" as I took a few years to decide what direction I was actually going. It started as block color over stencil then slowly morphed into a muted island scene and finally landed in my sweet spot: bright, bold, beautiful color with a varying range of detail. For example, some boats have multiple colors, sails, windows, and even reflections in the water, while others are nothing but a few delicate white brush strokes.

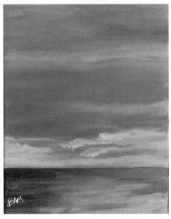

BLUE SKIES AND SANDY SHORES Brittany A. Mitchell 2020, acrylic canvas

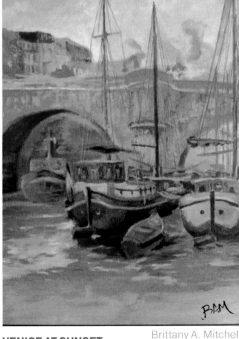

VENICE AT SUNSET Brittany A. Mitchell 2002, acrylic on canvas

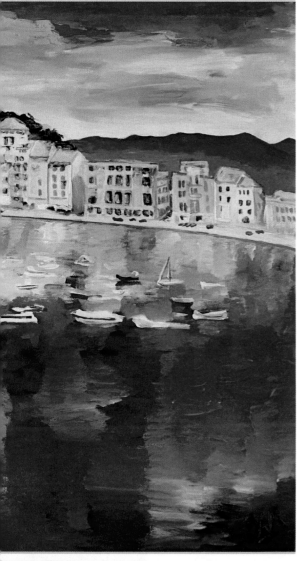

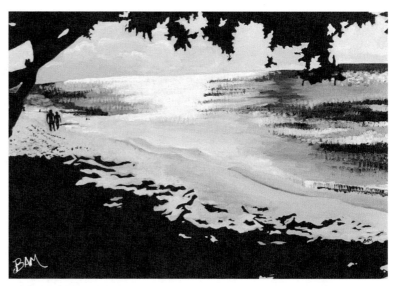

UNTIL WE MEET AGAIN

Brittany A. Mitchell
2017, acrylic on canvas

ABOUT THE ART

Britt: Hawaii is undeniably breathtaking and awe inspiring. I tried to capture the island's magnificence in *Haleakala Sunrise* from a photo that my mom captured. I wanted the clouds in the sky to form seemingly a whole different universe of shapes, color, and movement. In *Until We Meet Again*, the painting above, I wanted to show the beauty of Maui even without it's colorful palette. I took a negative space approach and painted with white acrylic on black canvas. The photograph used to create *Until We Meet Again* was the last photo I took before I headed back to the airport in 2016 from a work reward trip to Hawaii.

Lastly, the two paintings on the bottom left, *Destiny Awaits* and *Waiting to be Seated* are both watercolor paintings. My love for the beach definitely comes from my mom. The top painting is of my mom on the beach in Destin, FL. The bottom painting is another throwback to Hawaii, from a photo of the spectacular view as we were waiting to be seated at the famous Mama's Fish House. And yes, it was more than worth the wait!

Brittany A. Mitchell
2018-2021
acrylic on canvas

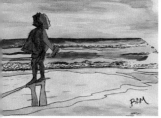

DESTINY AWAITS

Brittany A. Mitchell
2017, watercolor

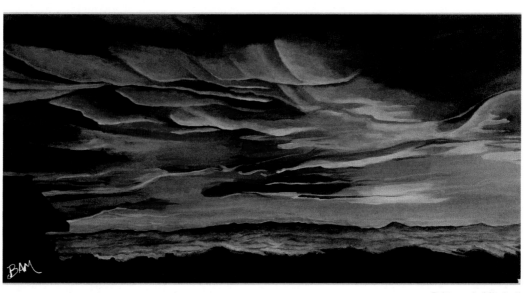

WAITING TO BE SEATED

Brittany A. Mitchell
2017, watercolor

HALEAKALA SUNRISE

Brittany A. Mitchell
2016, acrylic on canvas

Britt's Affirmations

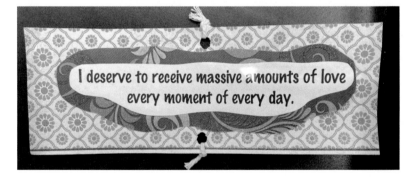

I am worthy of all the blessings, gifts, compliments, successes, benefits, and all the love that I receive.

I deserve to receive massive amounts of love every moment of every day.

Britt: Similar to mom's previous comments, my affirmations also came from being in a very dark place. At that time in my life, I did not believe in myself and I also lost my spark and my joy. I took all of my deepest insecurities and countered those negative insecurities with positive affirmations of what I expected from myself and my life. Once I completed writing these affirmations, I looked in the mirror each morning and said them out loud to my reflection until I started to believe them. These affirmations realigned me to my true north. So where do I go from here? Anywhere I want!

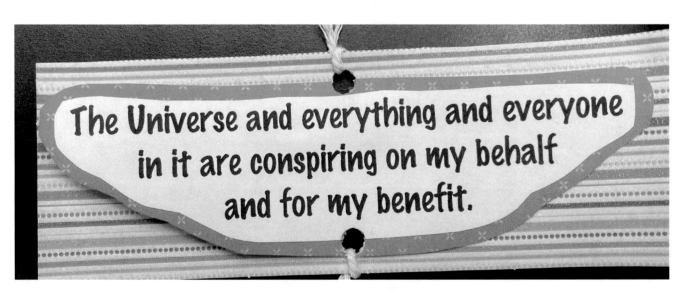

The Universe and everything and everyone in it are conspiring on my behalf and for my benefit.

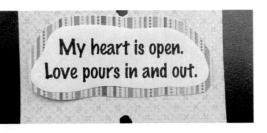

My heart is open.
Love pours in and out.

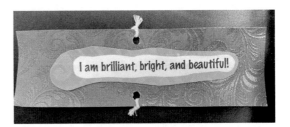

I am strong and healthy enough
to help others.

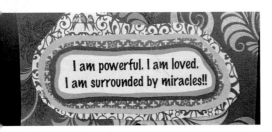

I am powerful. I am loved.
I am surrounded by miracles!!

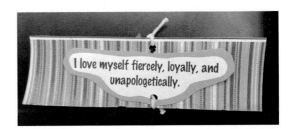

I am brilliant, bright, and beautiful!

Everything I desire today and will desire in
the future is here and available to me now.
I can have it all.

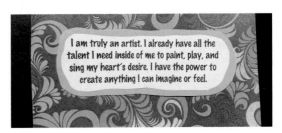

I love myself fiercely, loyally, and
unapologetically.

I choose to be curious instead of angry. I
choose to be empathic instead of
judgmental.

I am truly an artist. I already have all the
talent I need inside of me to paint, play, and
sing my heart's desire. I have the power to
create anything I can imagine or feel.

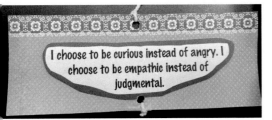

I am wise enough to observe and listen
before I speak and act.

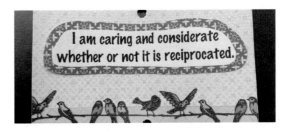

I am caring and considerate
whether or not it is reciprocated.

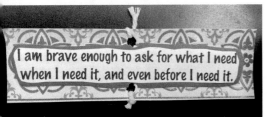

I am brave enough to ask for what I need
when I need it, and even before I need it.

I am smart enough to check my ego at the
door and remain ever grateful and humble.

Mom's Spaghetti Bolognese

INGREDIENTS:

- 1 GREEN BELL PEPPER (CHOPPED)
- 1 LARGE ONION (CHOPPED)
- 1 MEDIUM CARROT (CHOPPED)
- 1 PACKAGE SMOKED BEEF SAUSAGE (CHOPPED)
- 1 TBSP GARLIC (MINCED)
- 2 PACKAGES MUSHROOMS (SLICED)
- 3 LB GROUND CHUCK
- 3 CANS (14.5 OZ EACH) ITALIAN STYLE DICED TOMATOES
- ¾ CUP GOOD RED WINE
- 1 CAN (14.5 OZ) TOMATO SAUCE
- 1 CAN (19.5 OZ) TOMATO SOUP

INSTRUCTIONS:

Sauté chopped veggies in olive oil. Salt and pepper to taste. Add minced garlic.

Pour veggie mixture into a bowl. Sauté sausage and mushrooms. Add Italian seasoning and crushed red pepper to taste.

Pour sausage and mushroom mixture into the bowl. Cook ground chuck until brown. Season meat with kosher salt, ground black pepper, paprika, and Italian seasoning.

Pour seasoned meat into strainer to drain off grease. Once drained, add meat back to pot. Add veggies, mushrooms, and sausage back to pot as well. Add diced tomatoes, tomato sauce, and wine. Season to taste.

Cover and let simmer on med/low for two hours. Add ½ can of tomato soup (to taste). Pour finished bolognese over boiled spaghetti.

What's Next?

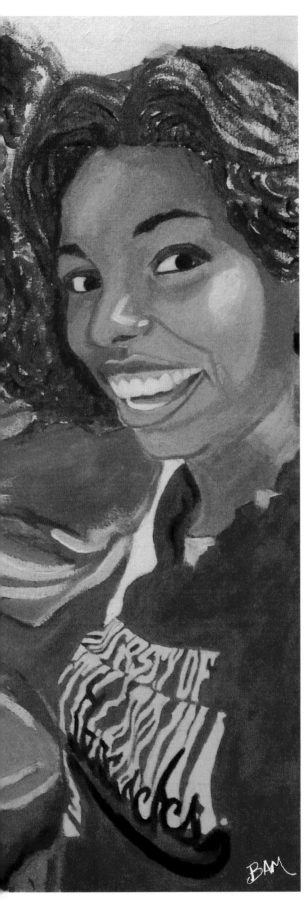

Britt: For our next grand adventure, we are creating a family legacy cookbook. From my great grandmother, Ethel Lockett (aka Gigi) to my grandmother, Deloris Powell to my mom, Rita Mitchell to me, Brittany Mitchell. Mom and I are writing this book for my future children (mom's future grandchildren) and beyond. It will show not only how to cook delicious food, but also why cooking is more than a hobby or a task. Through cooking we bind together family, deepen friendships, and feed our stomachs as equally as our souls.

Brittany A. Mitchell
2015, acrylic on canvas

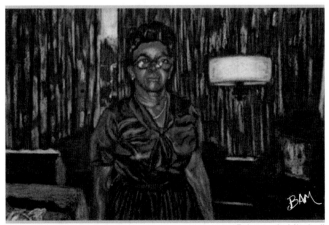

GIGI IN GULFPORT, MS

Brittany A. Mitchell
2003, color pencil on artboard

Before you go...

You may also enjoy Rita's first book, *Own Your Phenomenal Self: A Guide on Character, Success, and Leadership*.

ABOUT THE BOOK

Renowned entrepreneur and corporate executive Rita P. Mitchell serves as guide and mentor for the reader, taking her through the three core building blocks that lead to becoming phenomenal: character, success, and leadership. In her classic storytelling style, Rita shares her secrets to success, giving young women the tools they need to tap into their power and showing them how to own it.

Filled with profound wisdom, encouraging anecdotes, and practical takeaways, Own Your Phenomenal Self is an unflinching, unfiltered tap into the wisdom and strategic prowess of a female executive who created success on her own terms and who knows how to create success for others. By following Rita's lead and the advice in this book, young women will learn that they alone get to determine their value, their worth, and their destiny, and they will be equipped to confidently set a course for their desired success.

Are you ready to embrace your phenomenal self? It's time to shift your mindset, knock down obstacles, and stand in your power.

"This book is a 'Portable Mentor' for women at all stages of their career.

It helps a reader recover quicker from the inevitable career pains and persevere towards the possibilities of your career when you stay the course.

There is power in these pages and you'll find yours at the end of it."

Christina A. Coleman
Private Client Strategy
Executive

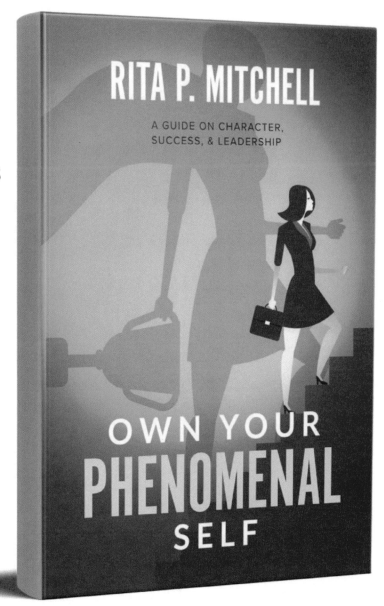

Shop the Art

www.redbubble.com/people/brittanyart/shop

brittanyart
Brooklyn, United States

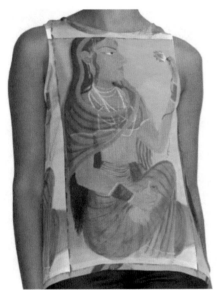

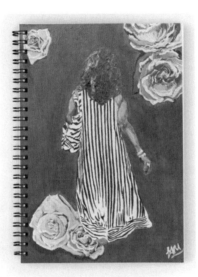

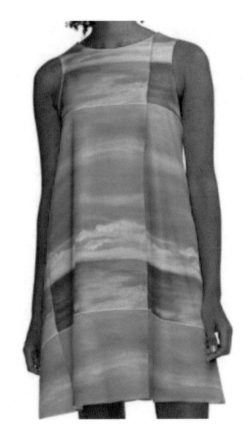

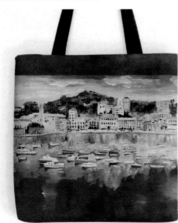

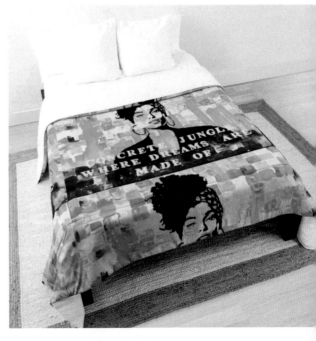

Find a broad selection of merchandise
that brings Britt's art to life.

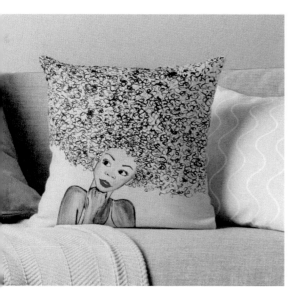

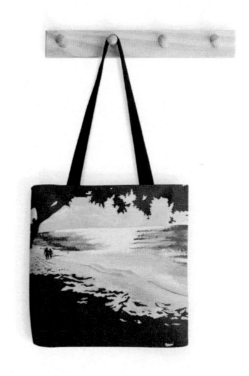

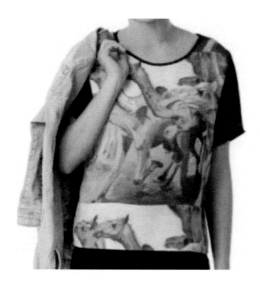

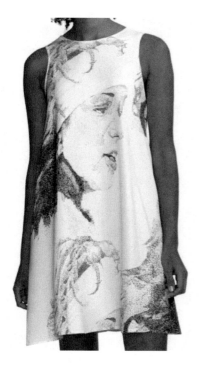

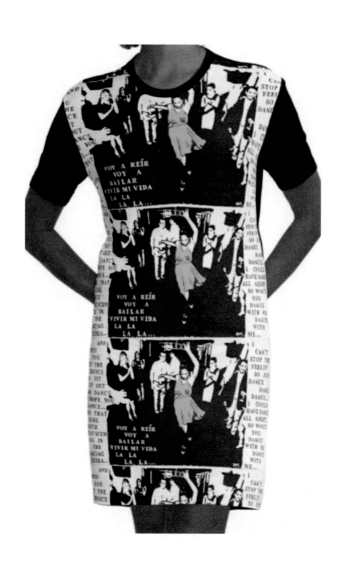

Spoken Art

Too Brave to Back Down

Rita P. Mitchell and Brittany A. Mitchell

Made in United States
Orlando, FL
04 December 2021

11093181R00022